My father, Martín Eugenio ALZÓN BARCELONA, Navarrese (Pamplona, 1921-Valcarlos, 2014), signed his paintings E. MAB (Eugenio Martín ALZÓN BARCELONA). A painter of genius, he wrote at the time of his only exhibition, in favor of the Anti-Tuberculosis League of Miranda State in Venezuela: "I paint trees for their incomparable plastic beauty and as a way of manifesting my solidarity and concern for the fate of these powerful but equally fragile examples of life in front of a progress, devoted to the disaster, which is destroying them. I paint houses, typical old houses, heirs of an ethic and aesthetics typically Venezuelan, because a voracious infatuation for foreign customs and fashions is abandoning them and the values that they represent. I paint landscapes, natural and cultural landscapes, as an interpretation of the existential roots and the experience of Man, his being and his way of being. Woe to the country that allows the deterioration of its cultural modes and its natural environments, because it is thus

deteriorating its identity and its own existence! ".

SINCE ALWAYS, I HAVE SEEN MY FATHER PAINTING LANDSCAPES AND TYPICAL HOUSES, IN VENEZUELA AS IN THE BASQUE COUNTRY, WITH A WINK TO SOCIAL AND HISTORICAL REALITIES.

My father has always written. I therefore collected after his death all its texts, which I published under the title of "Ensayos".

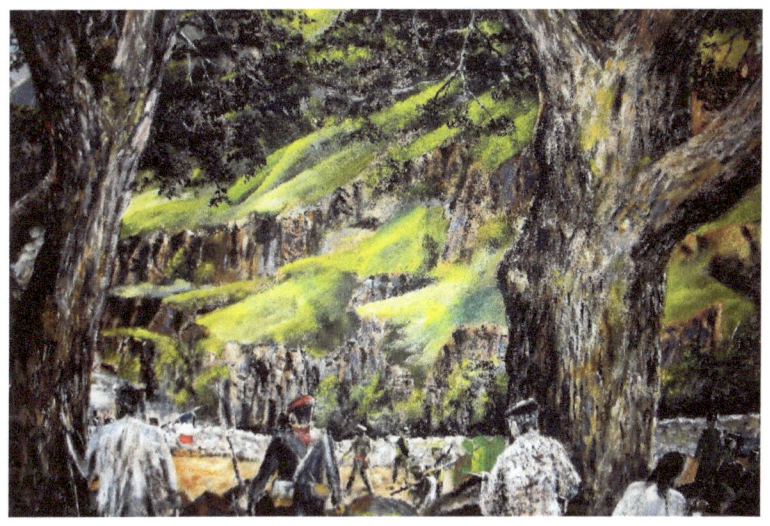

Basques in history.

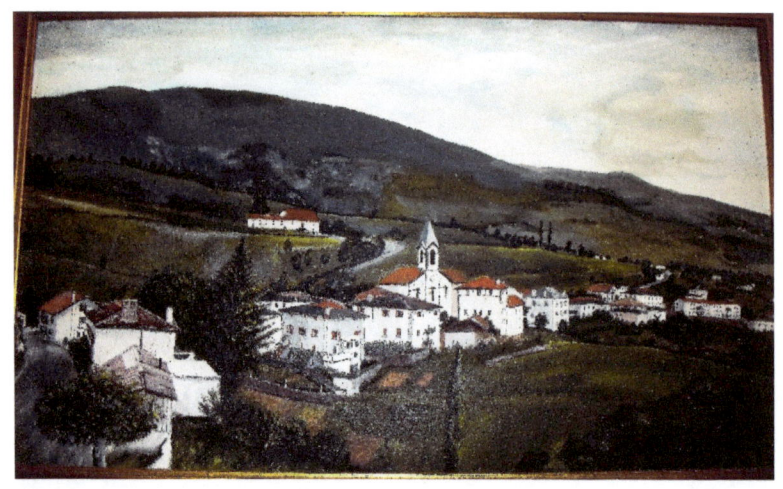

Valcarlos. Navarre.

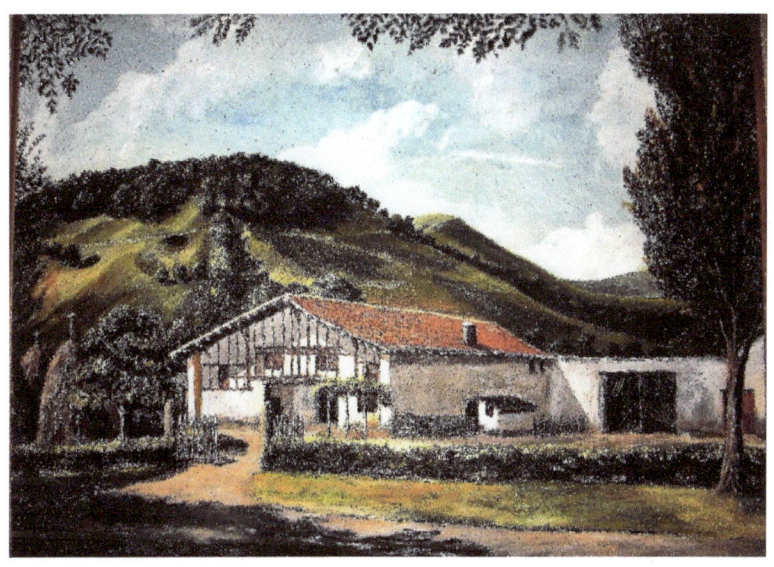

Basque Country.

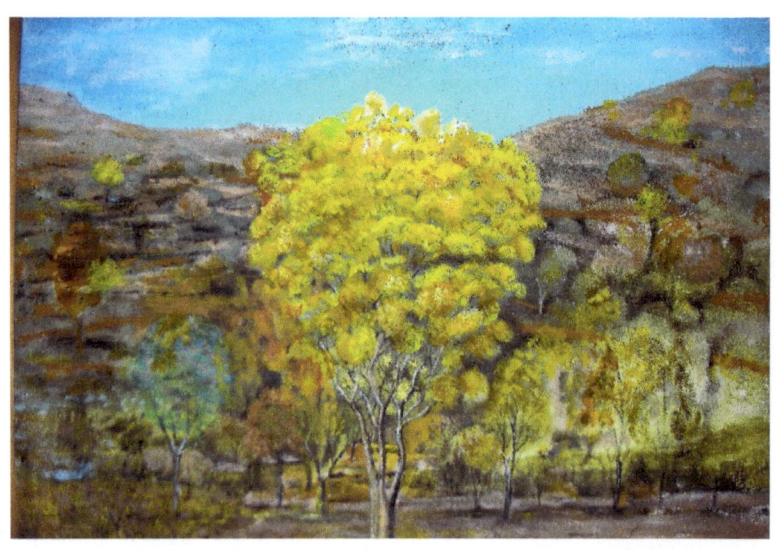

The Araguaney, the national tree of Venezuela. Painted in Valcarlos. Last painting painted by my father.

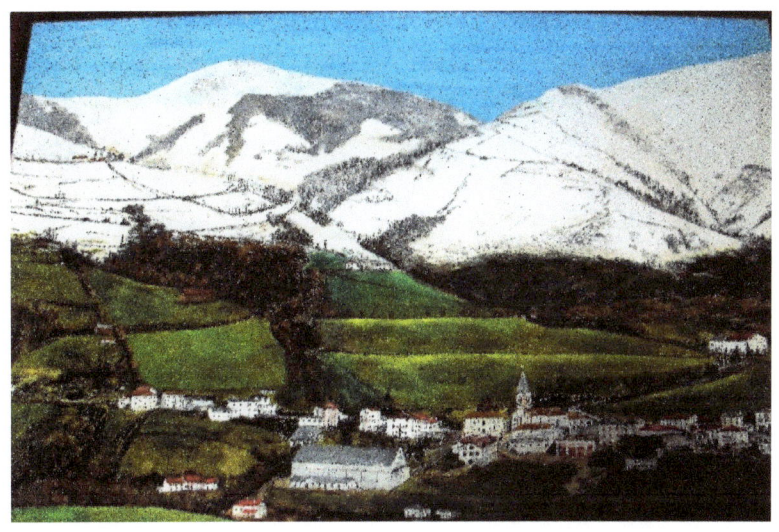

Valcarlos. Navarre.

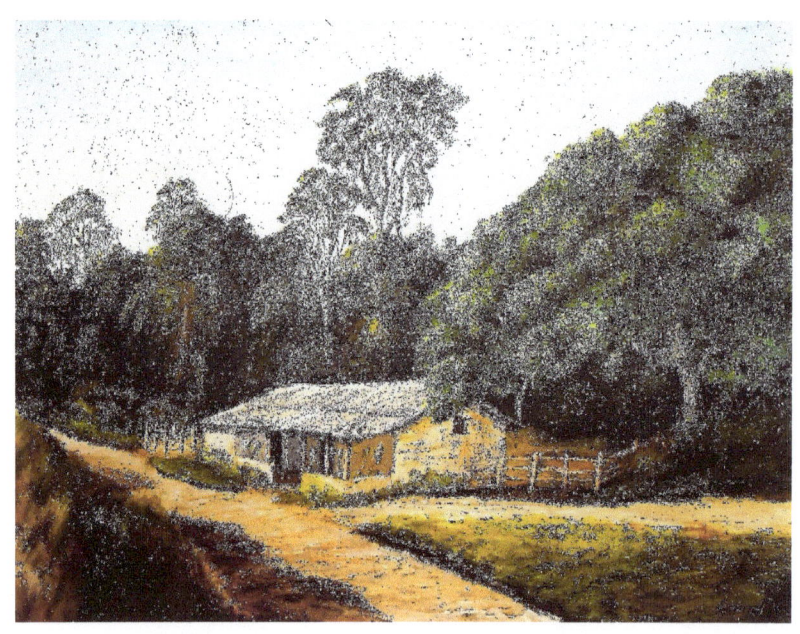

Venezuela.

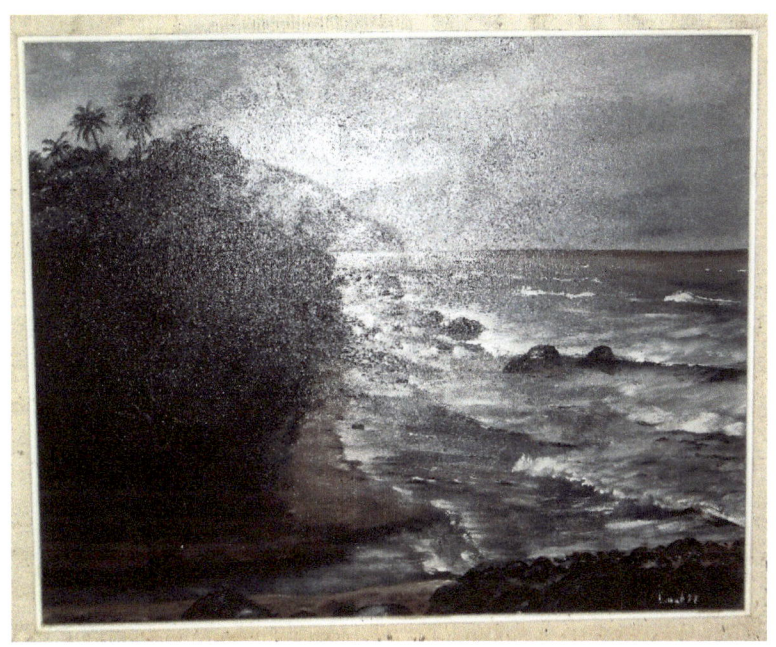

Venezuela. Puerto Colombia (Choroní).

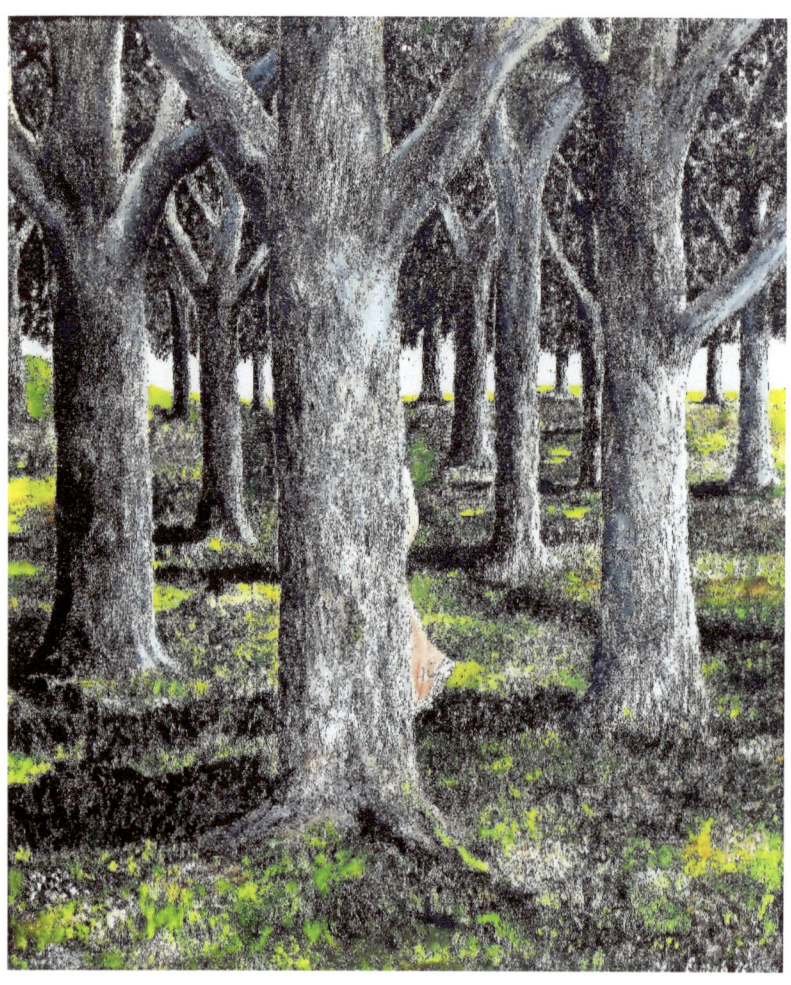

Venezuela.

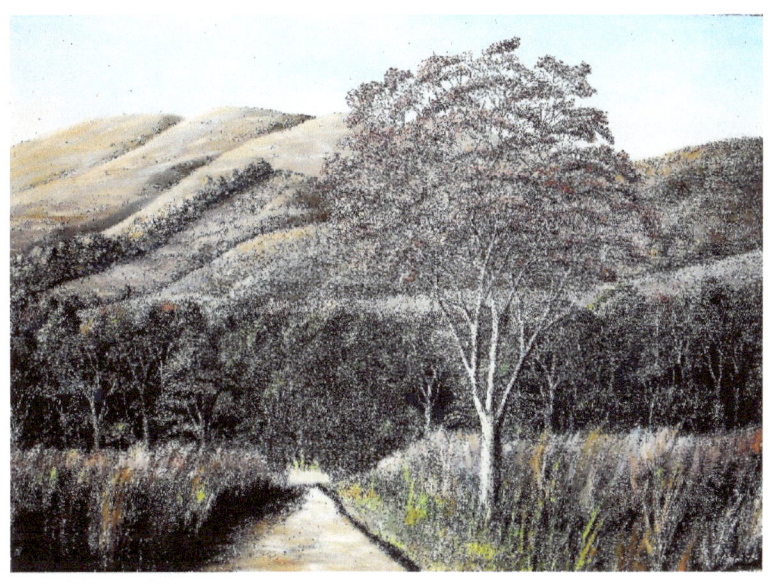

Venezuela.

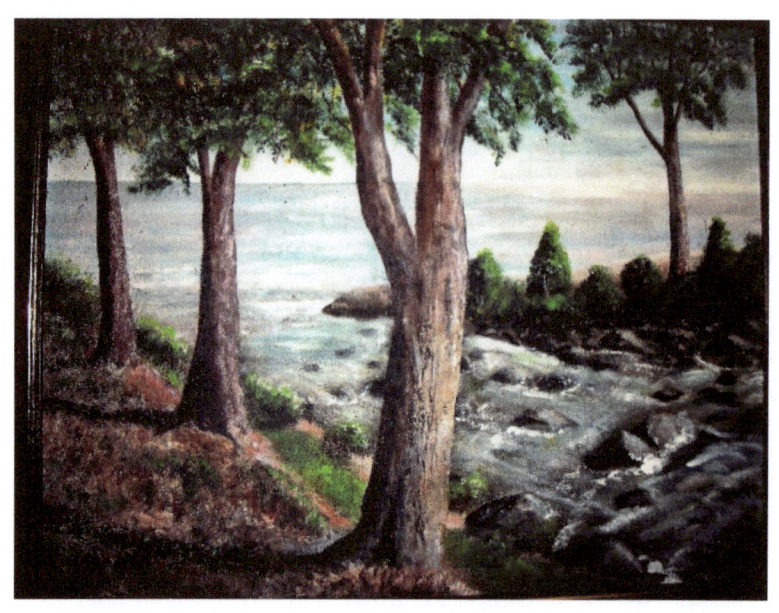

Imaginary landscape. Painted in Navarre.

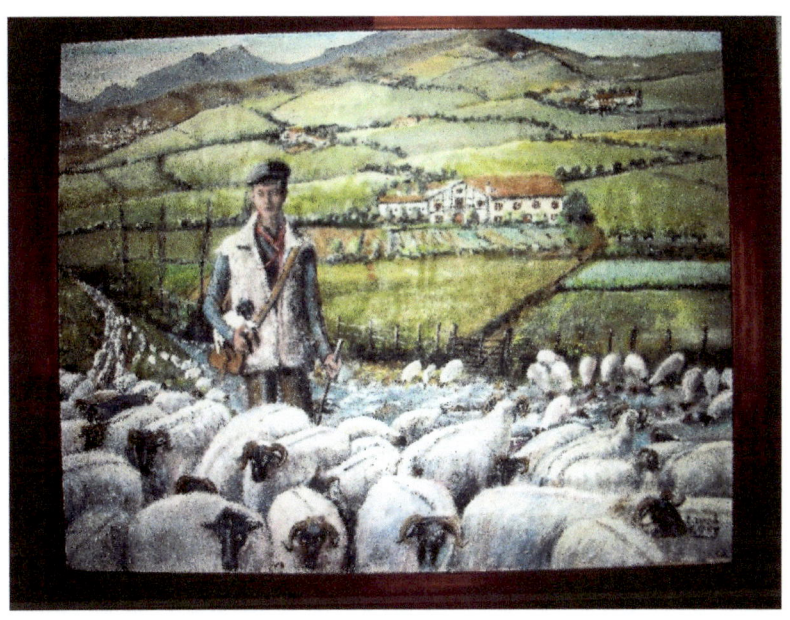

Basque shepherd.

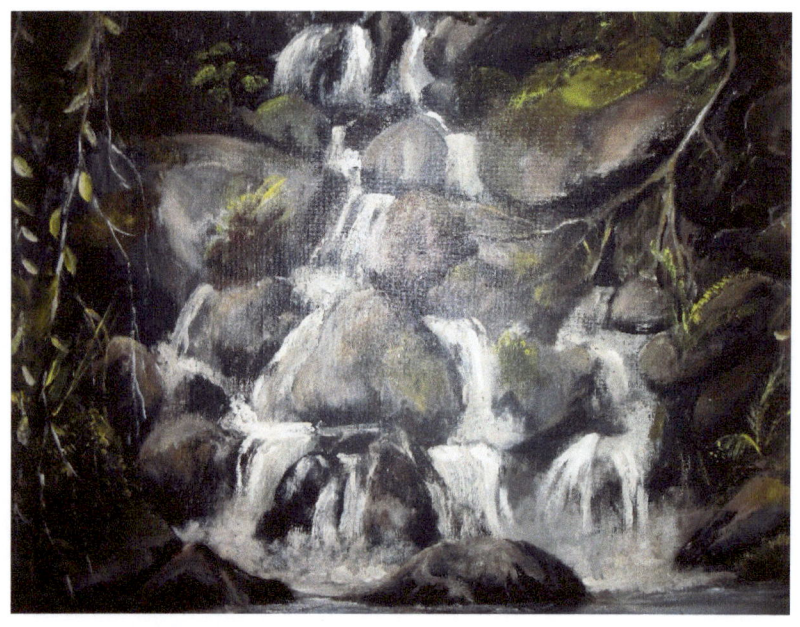

Venezuela.

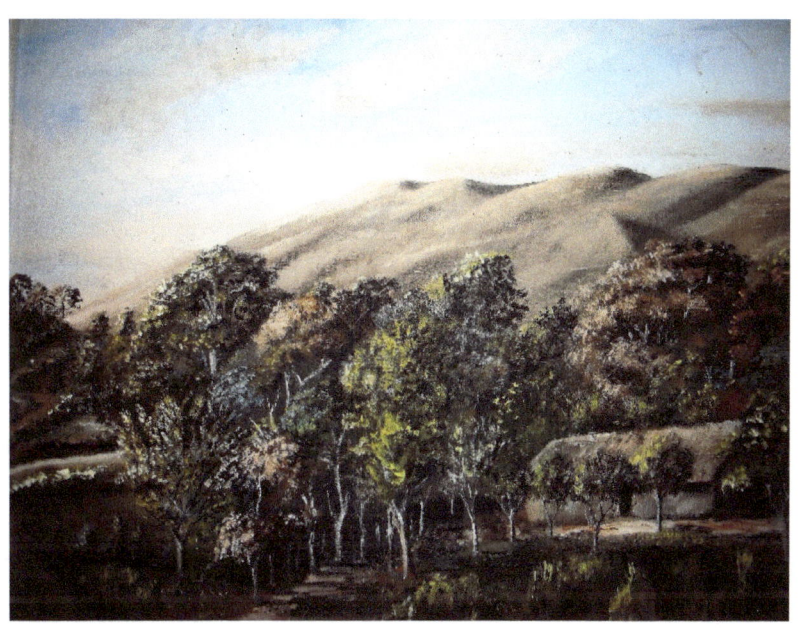

Venezuela.

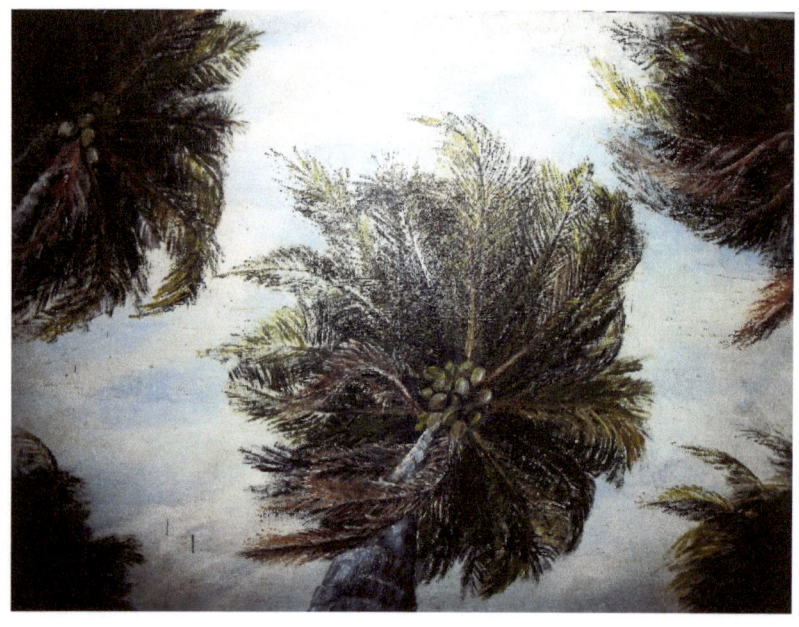

Venezuela.

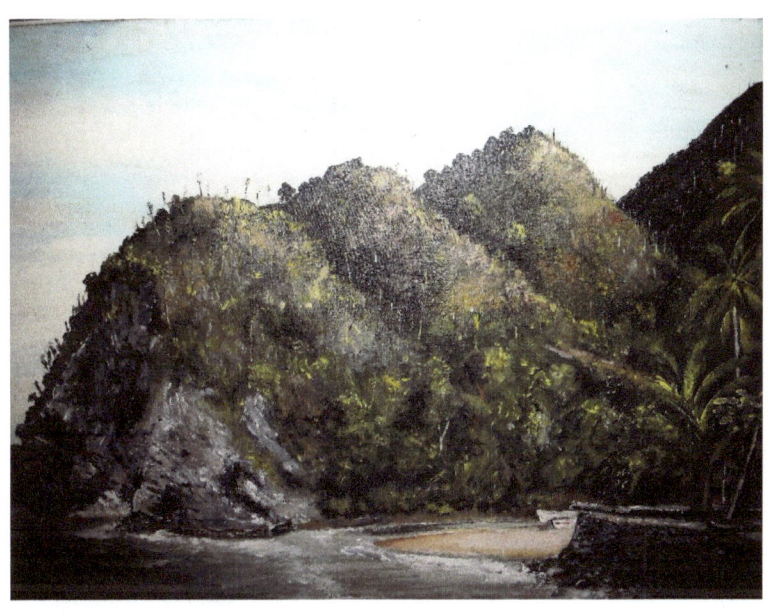

Venezuela. Puerto Colombia (Choroní).

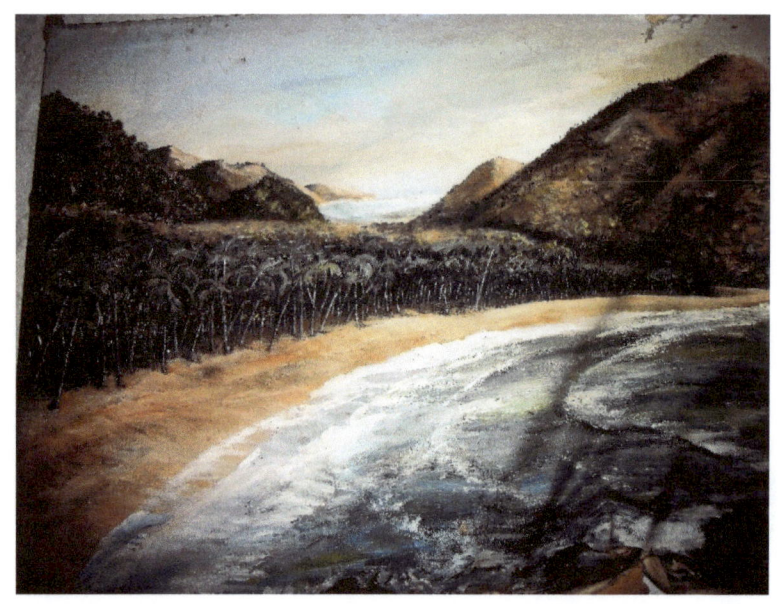

Venezuela.

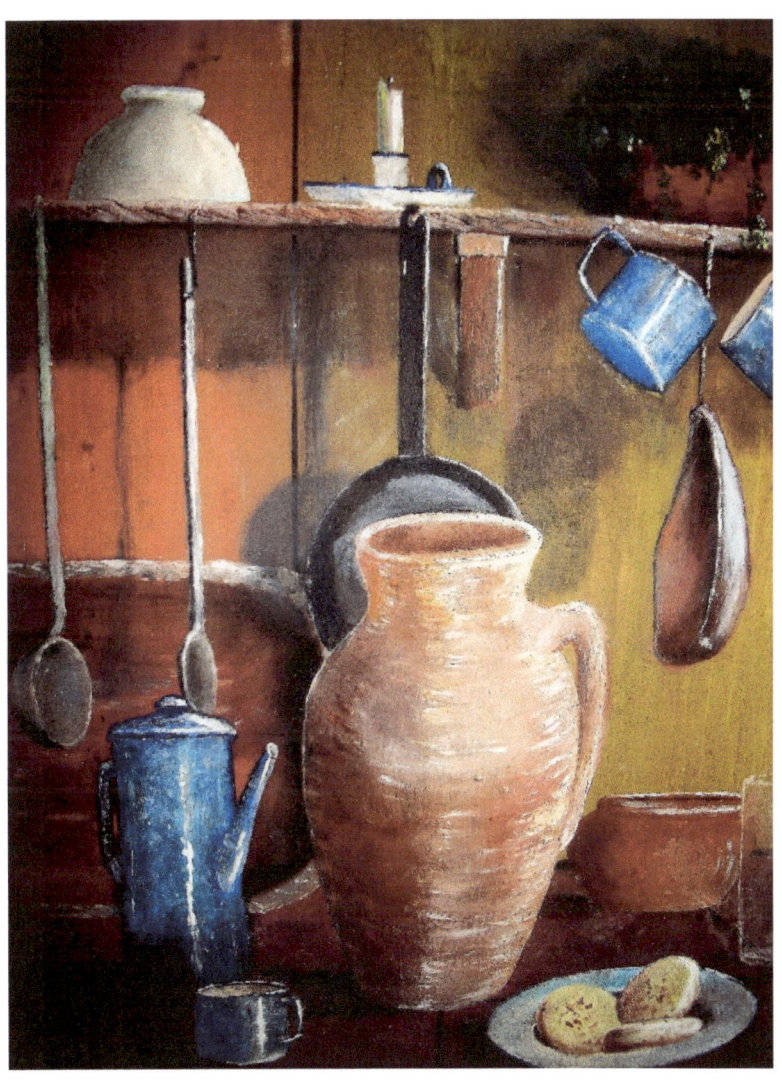

Venezuela. At the bottom right corner, some "arepas".

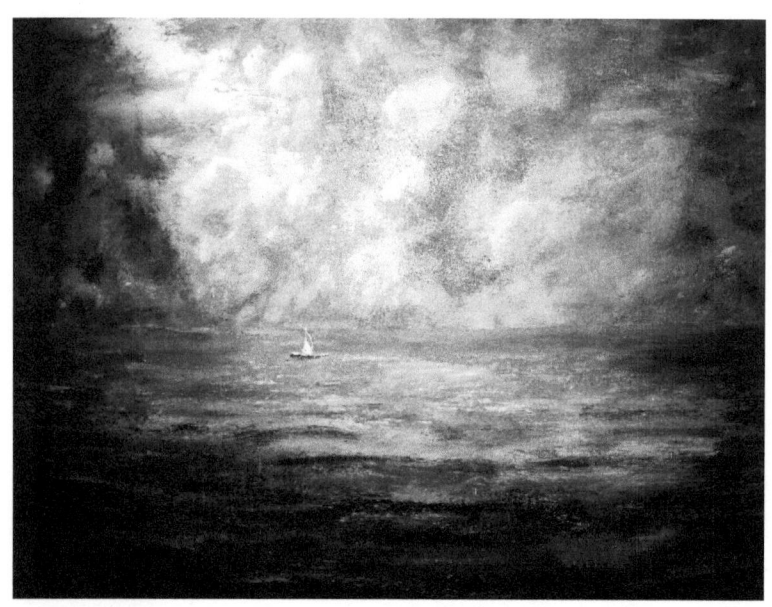

Venezuela.

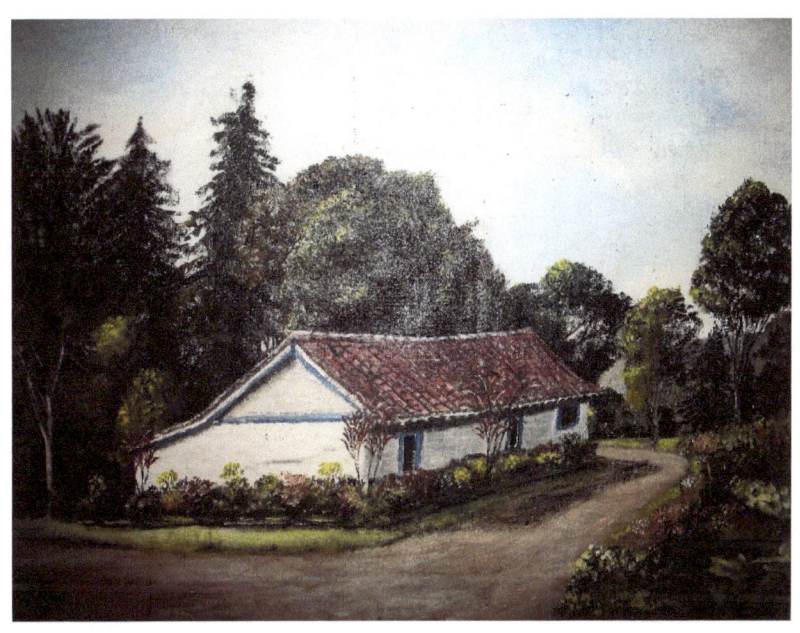

Venezuela. Around San Pedro de los Altos.

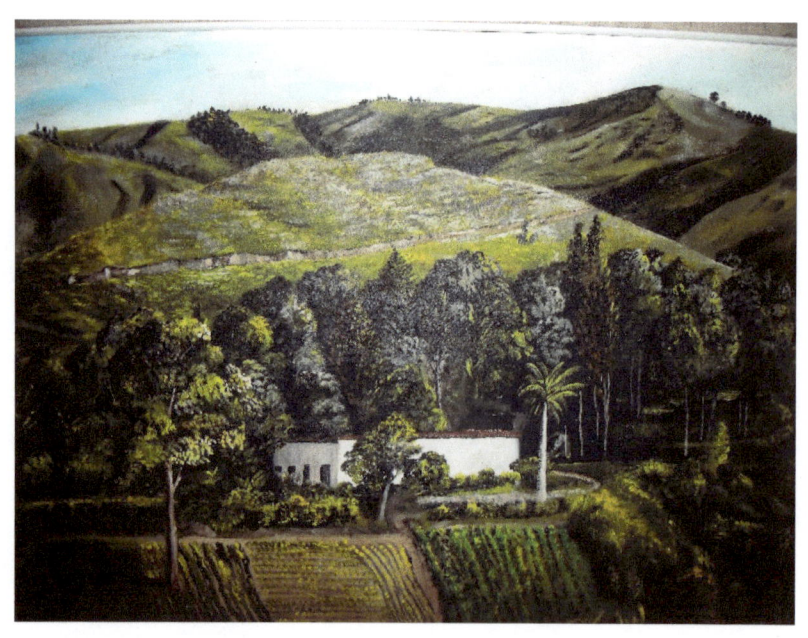

Venezuela. Around San Pedro de los Altos.

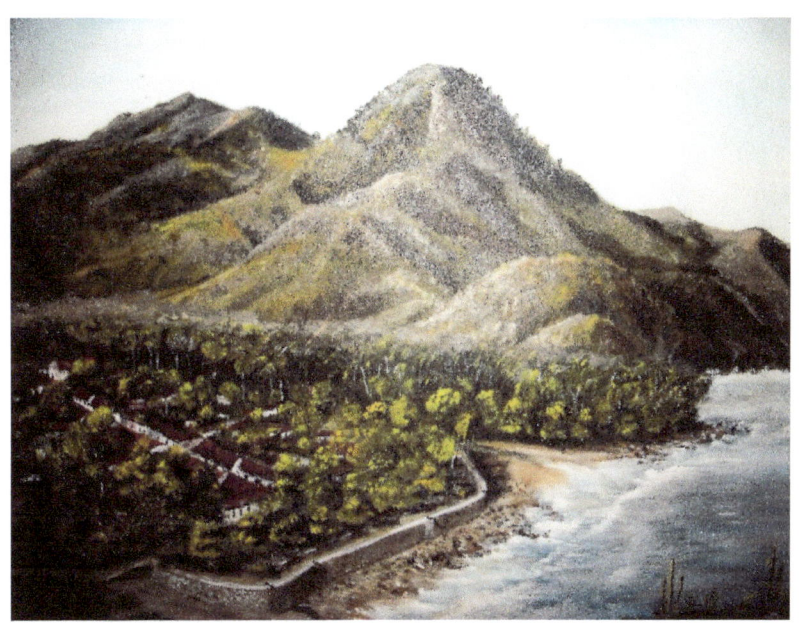

Venezuela. Puerto Colombia (Choroní).

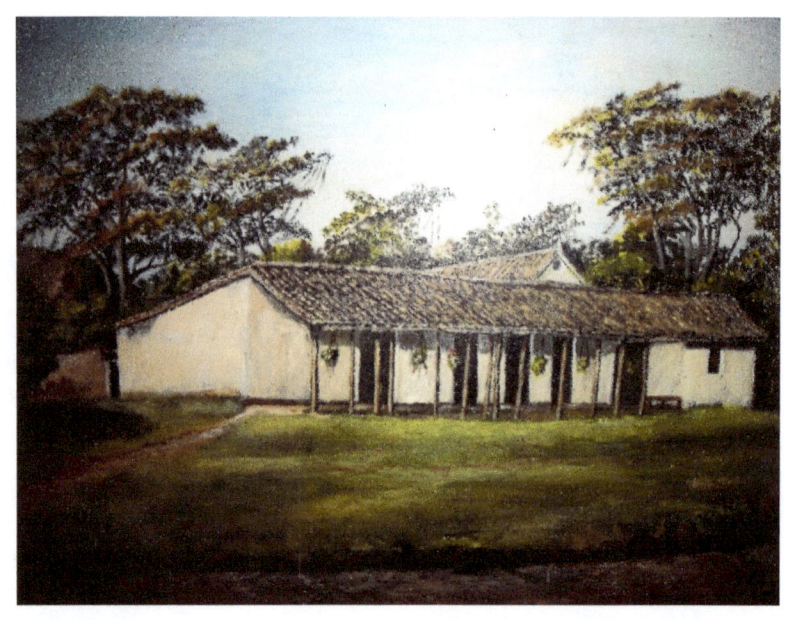

Venezuela. Around San Pedro de los Altos.

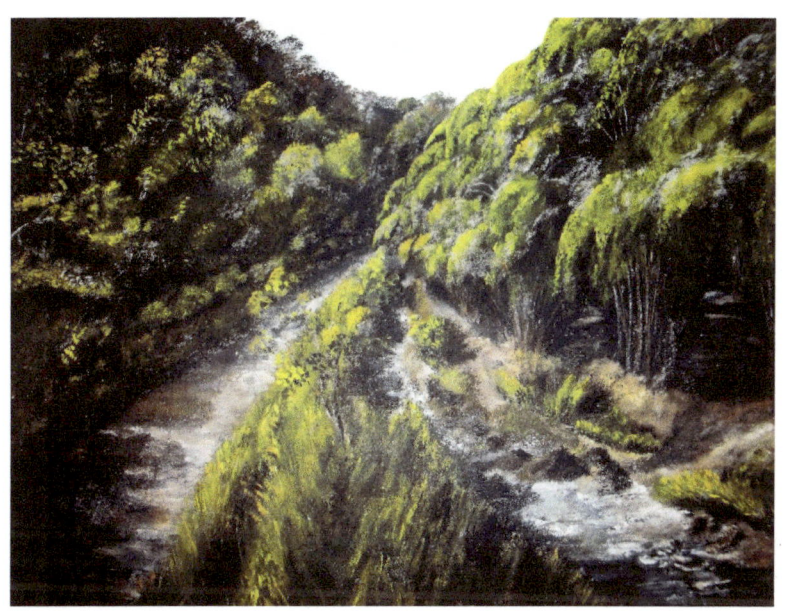

Venezuela.

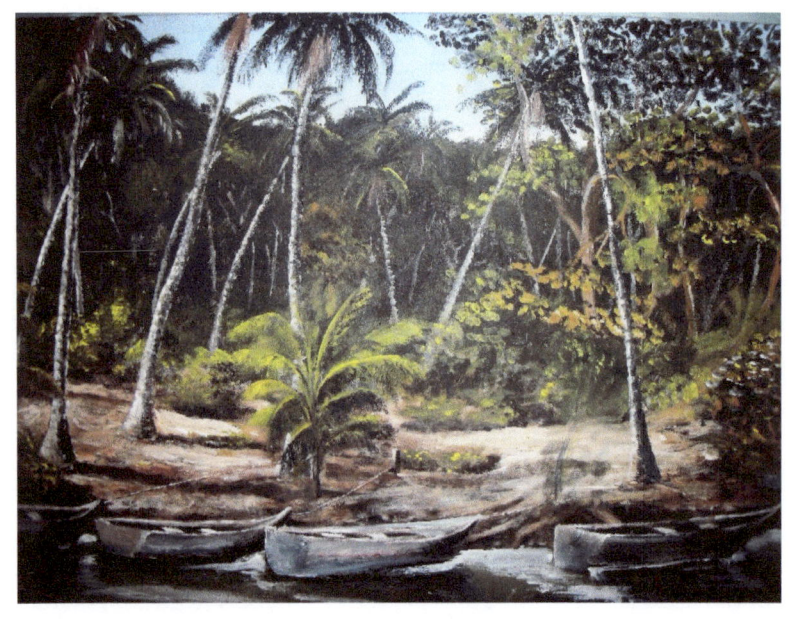

Venezuela. Puerto Colombia (Choroní).

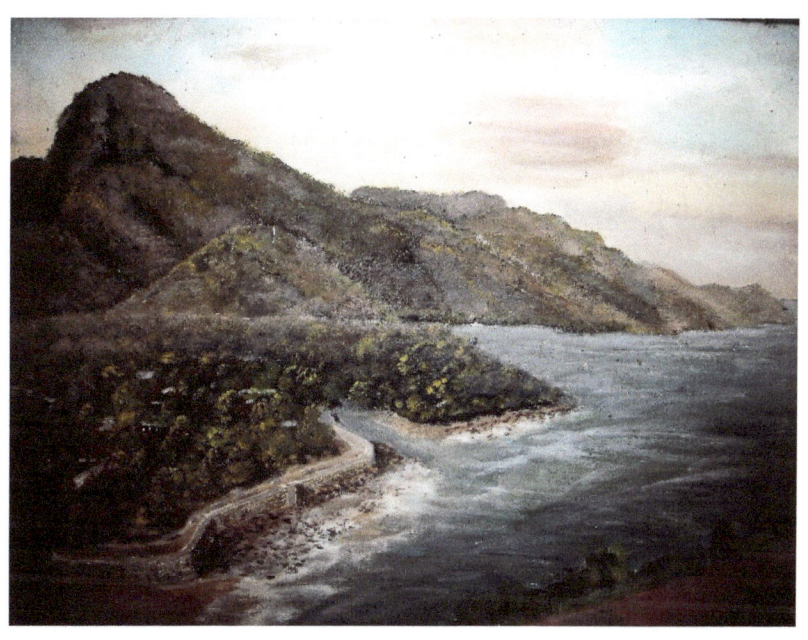

Venezuela. Puerto Colombia (Choroní).

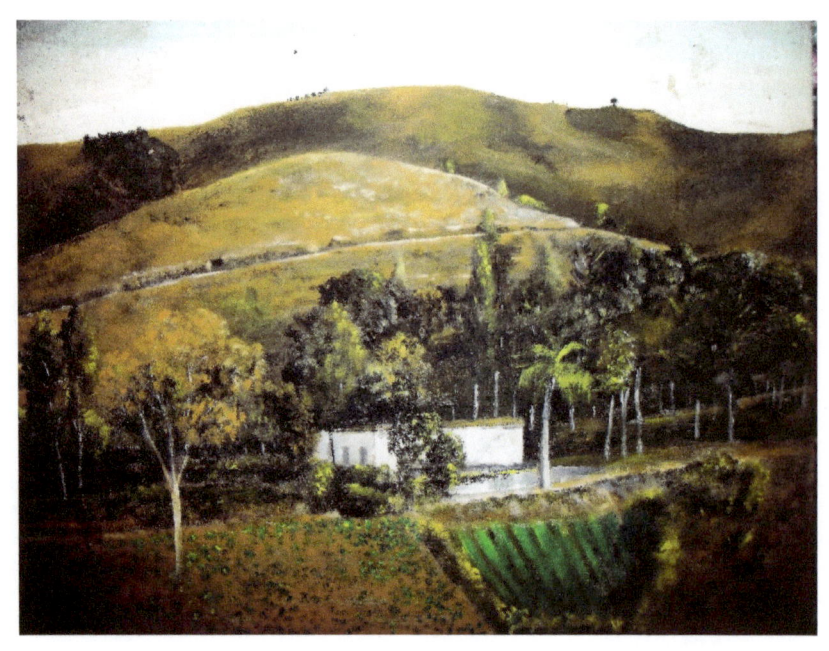

Venezuela. Around San Pedro de los Altos.

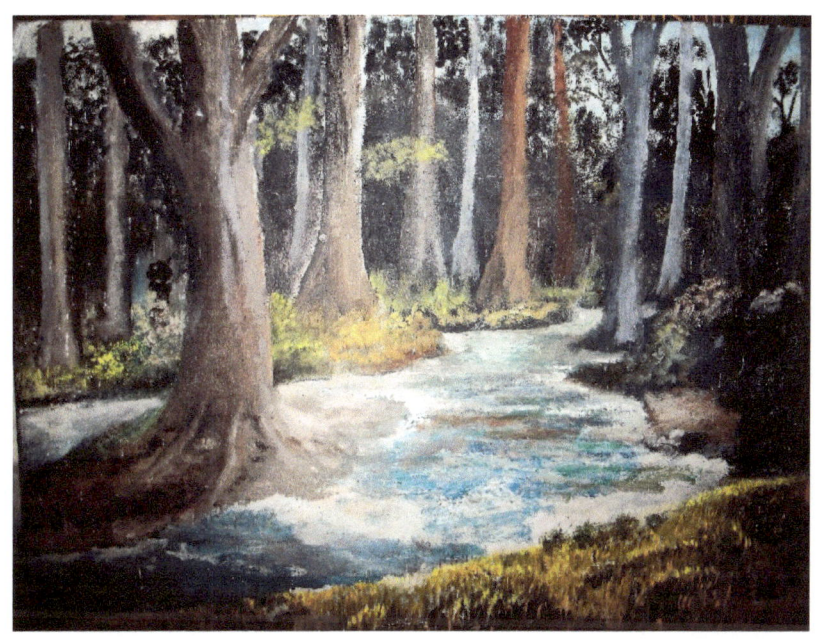

Venezuela.

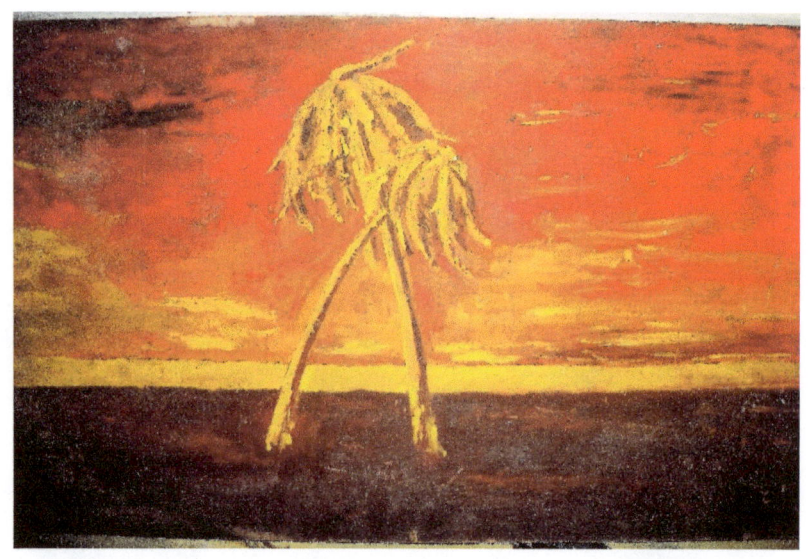

Venezuela.

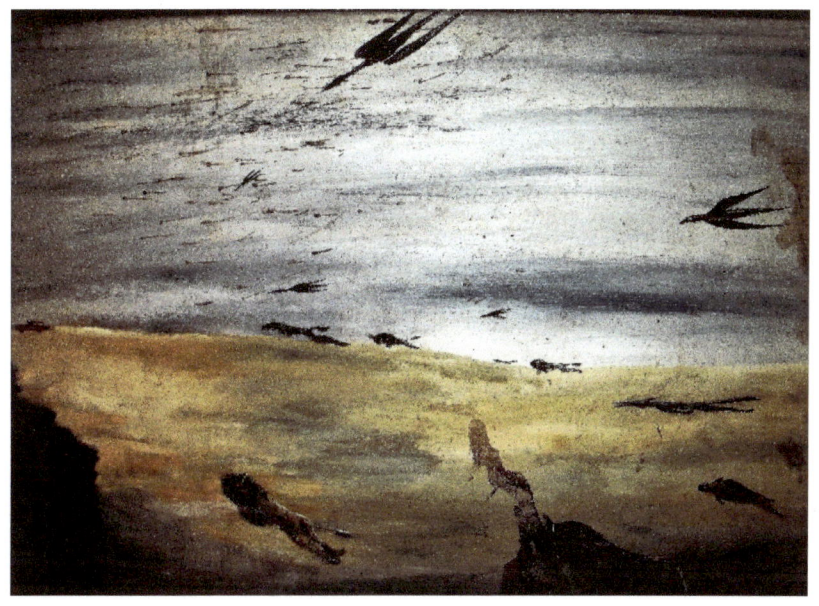

Venezuela.

Venezuela.

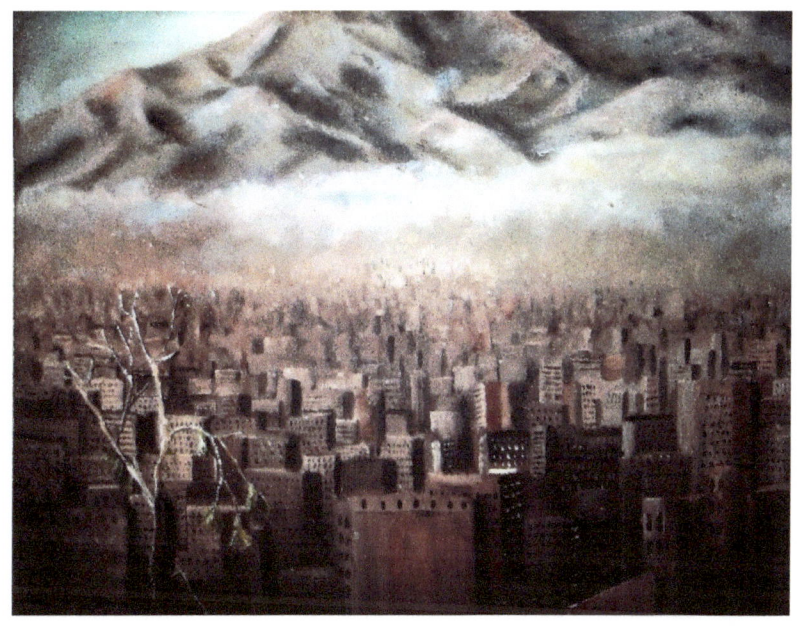

Venezuela.

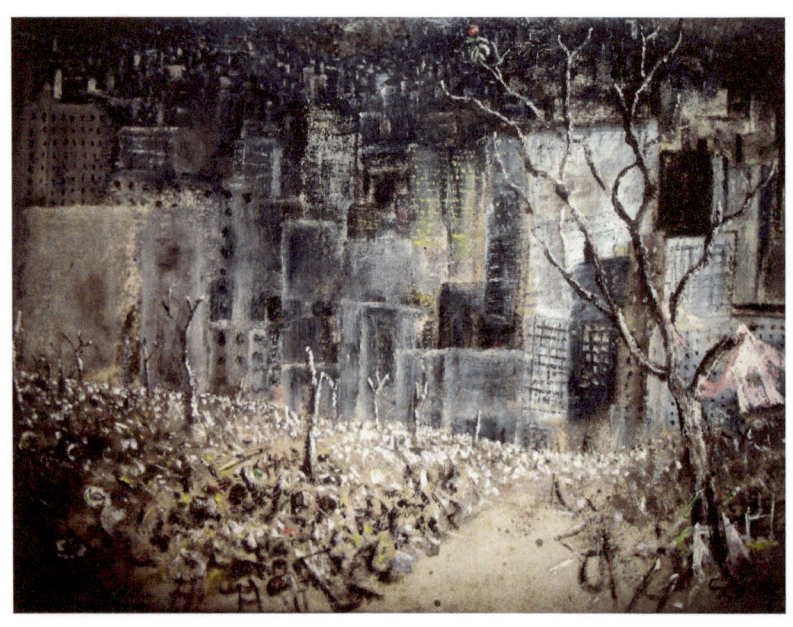

Venezuela.

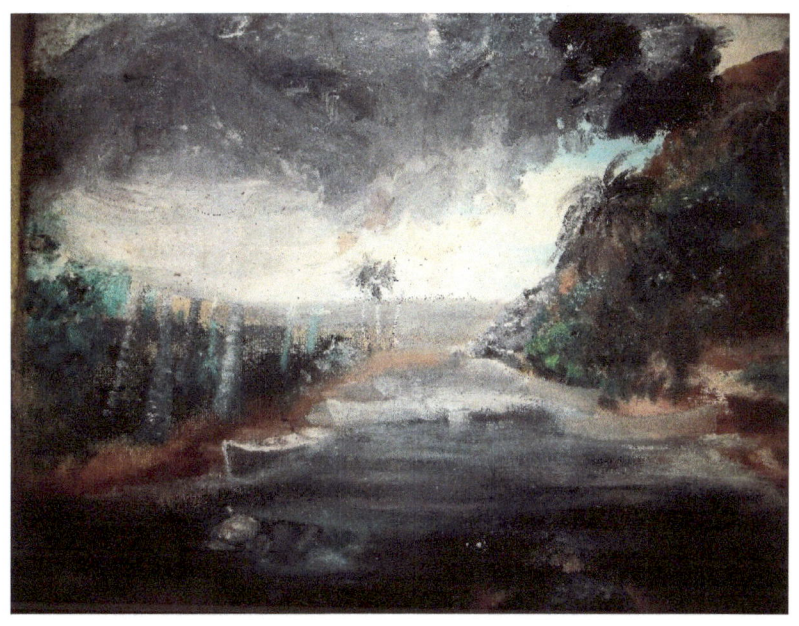

Venezuela. Puerto Colombia (Choroní).

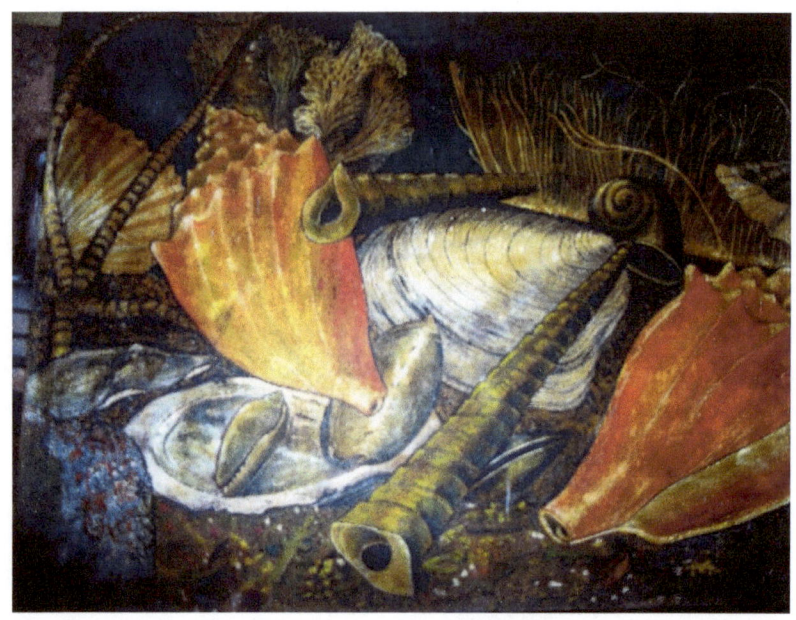

Venezuela.

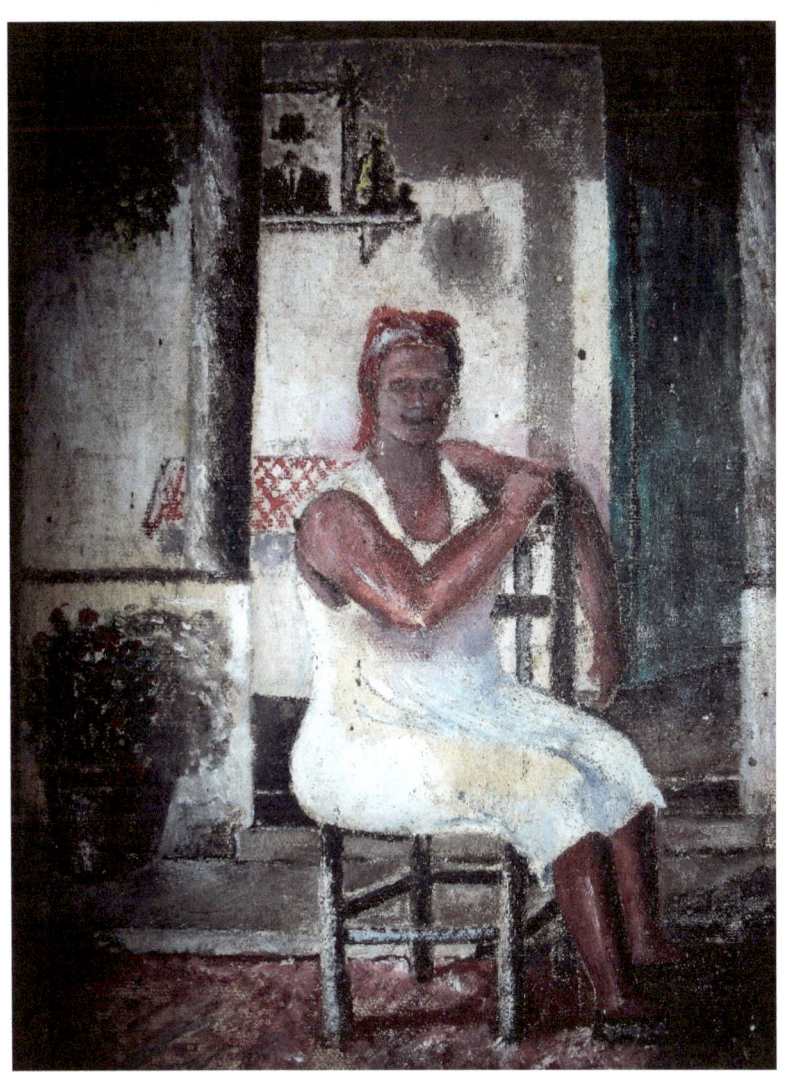

Venezuela.

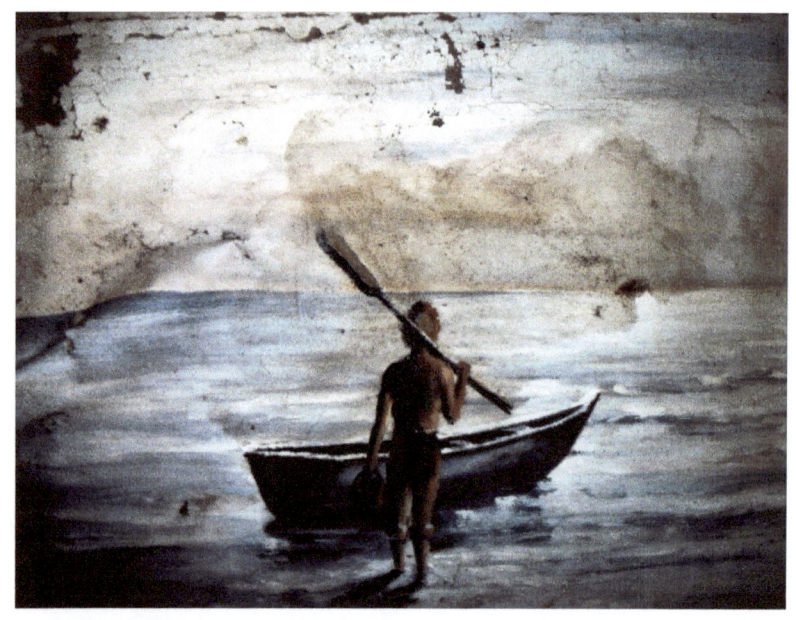

Venezuela.

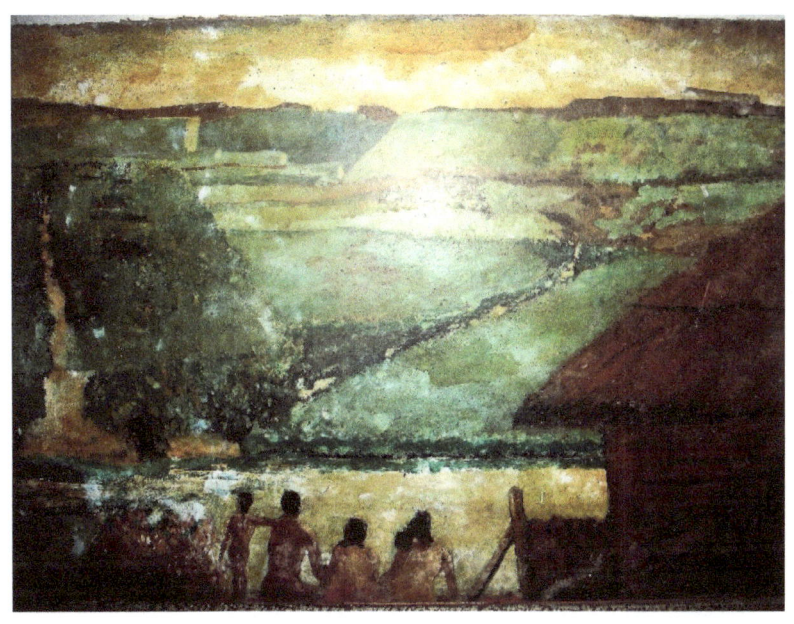

Venezuela. The Pemon in their Gran Sabana.

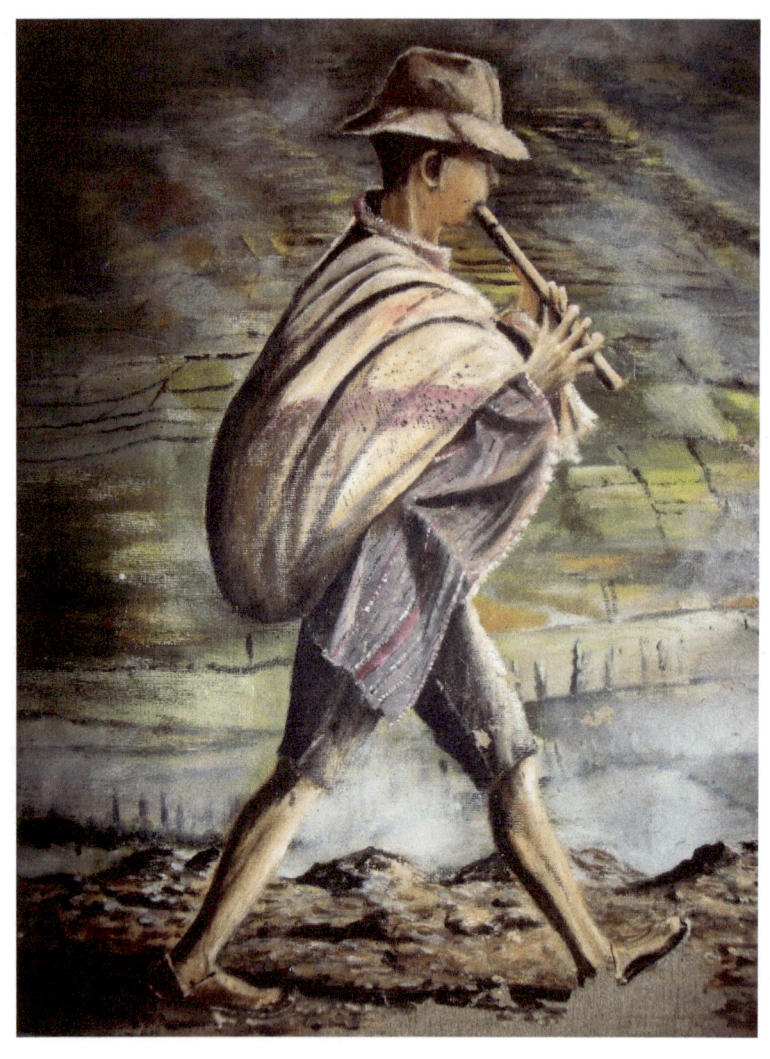

Small flute player of the Andean Altiplano.

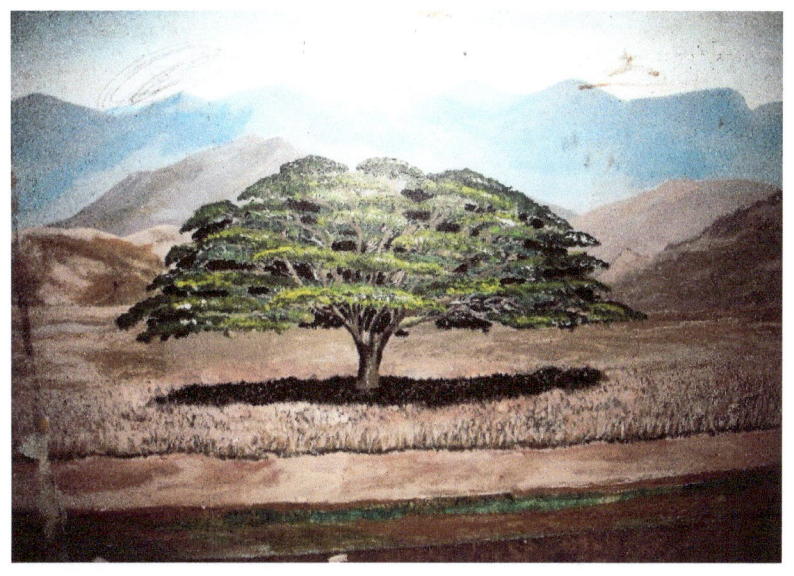

The samán, emblematic Venezuelan tree.

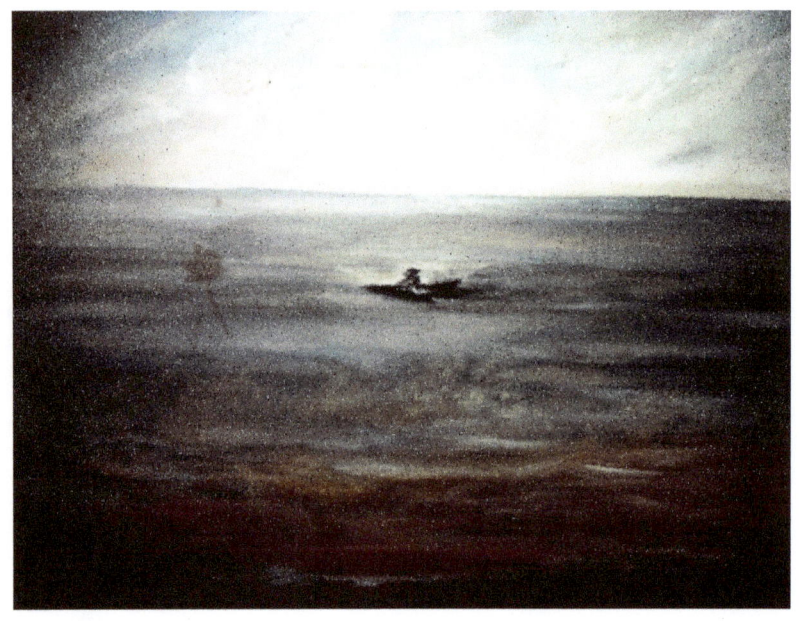

Venezuela.

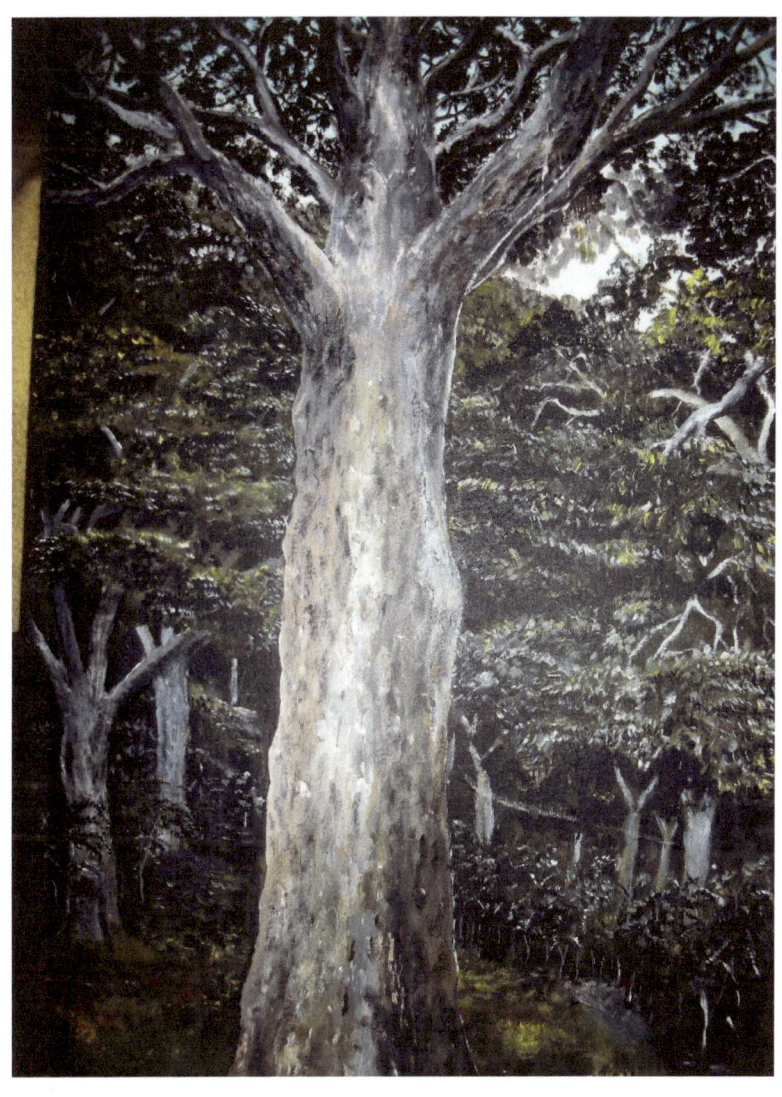

Venezuela.

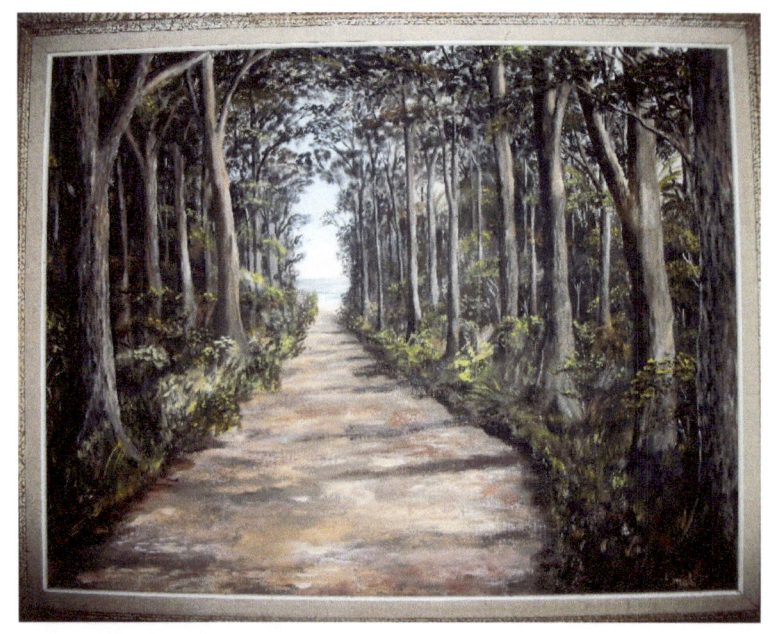

Venezuela.

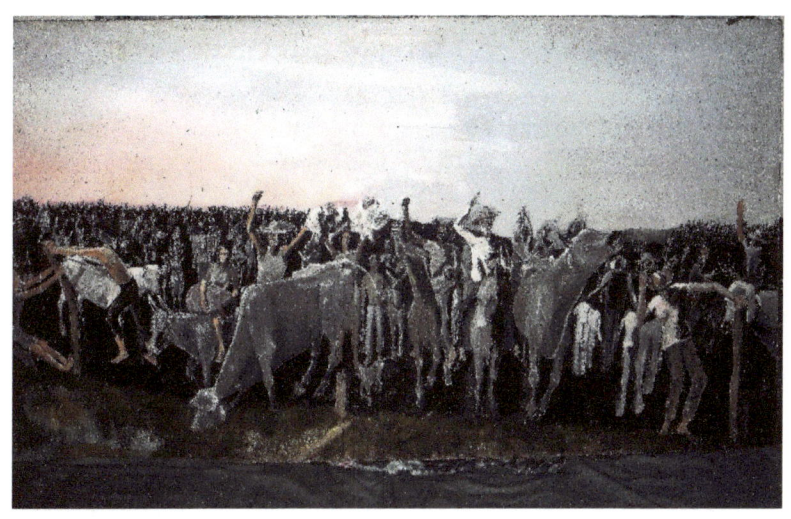

Venezuela.

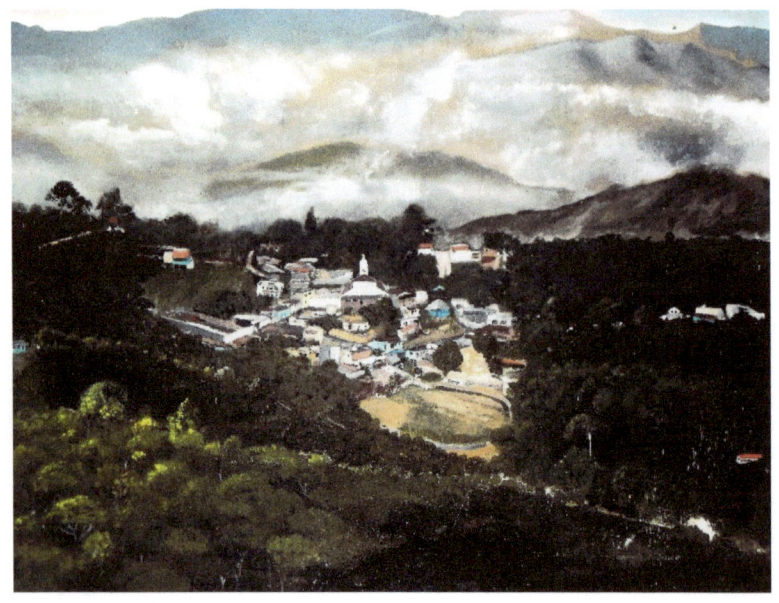

Venezuela.

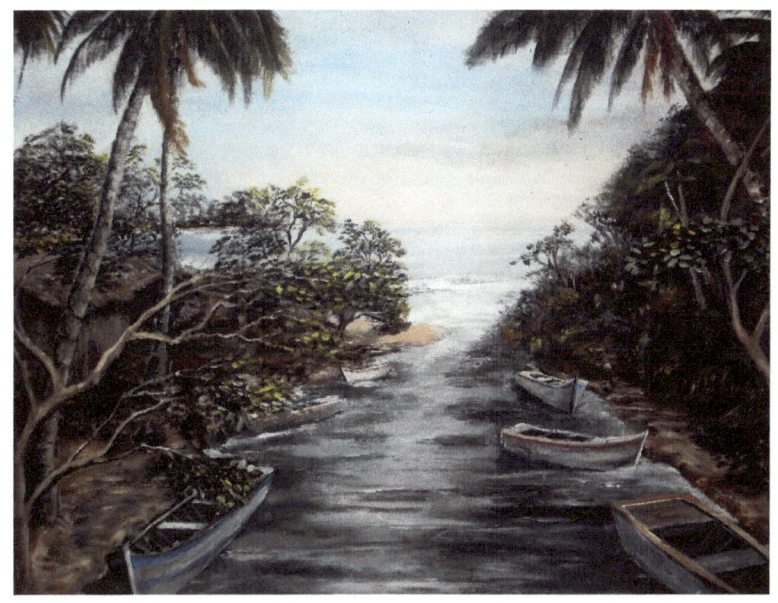

Venezuela. Puerto Colombia (Choroní).

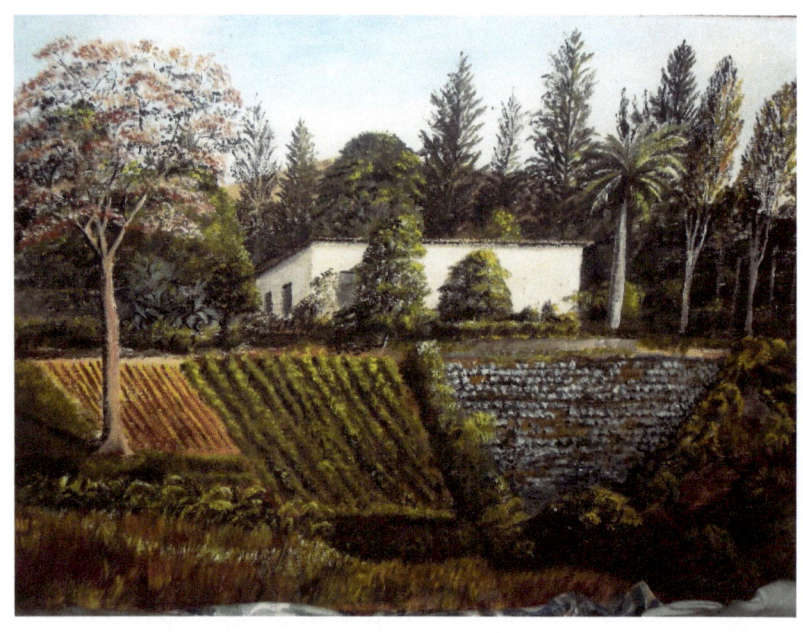

Venezuela. Around San Pedro de los Altos.

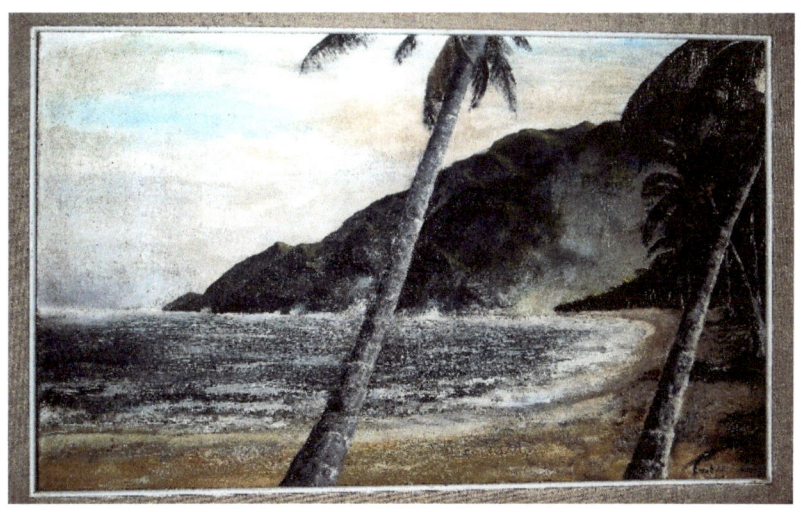

Venezuela. Puerto Colombia (Choroní).

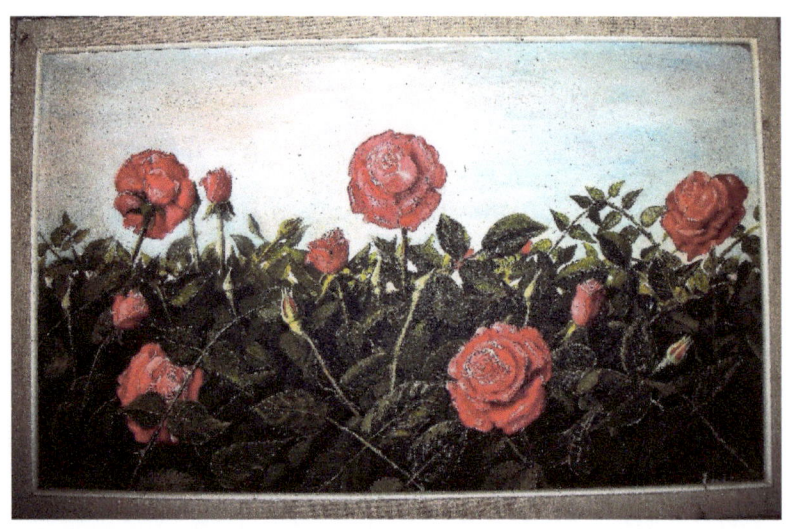

Venezuela.

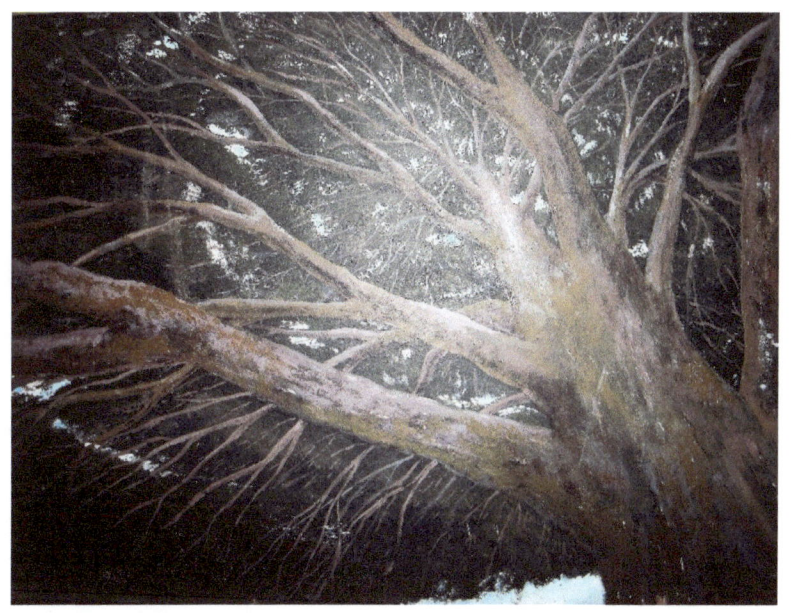

Venezuela.

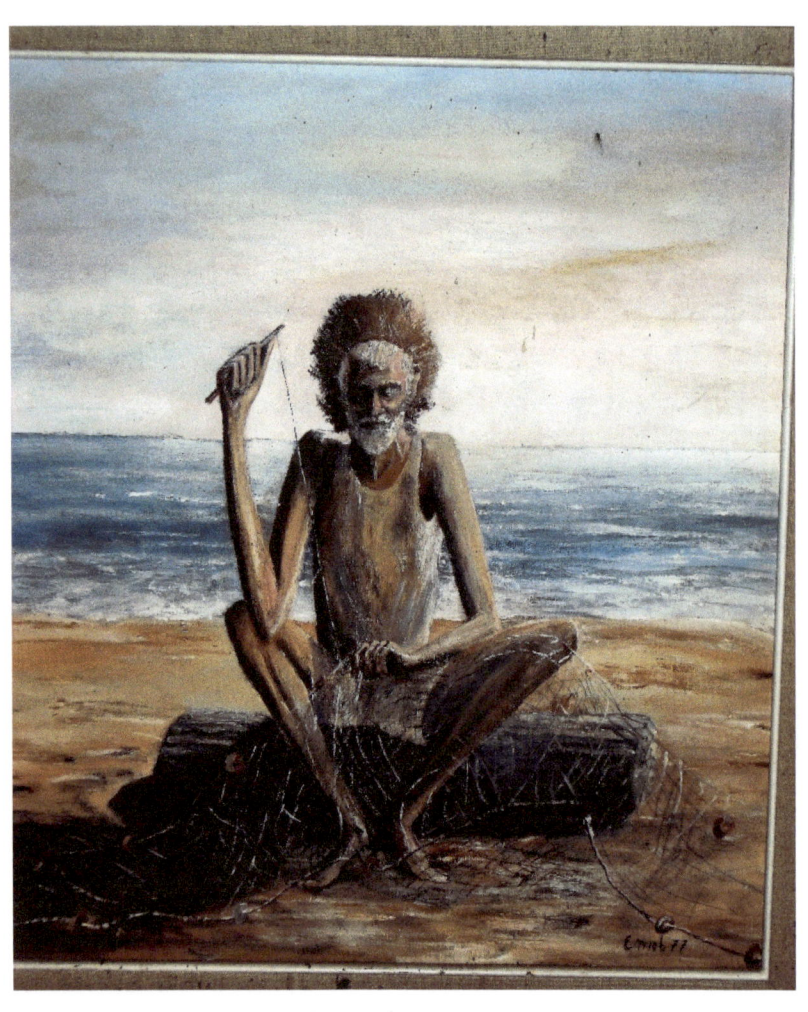

Venezuela.

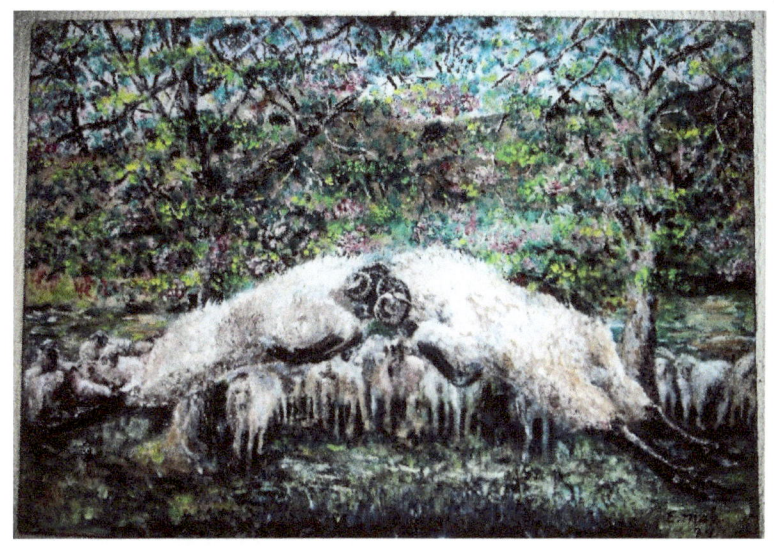

Basque Country.

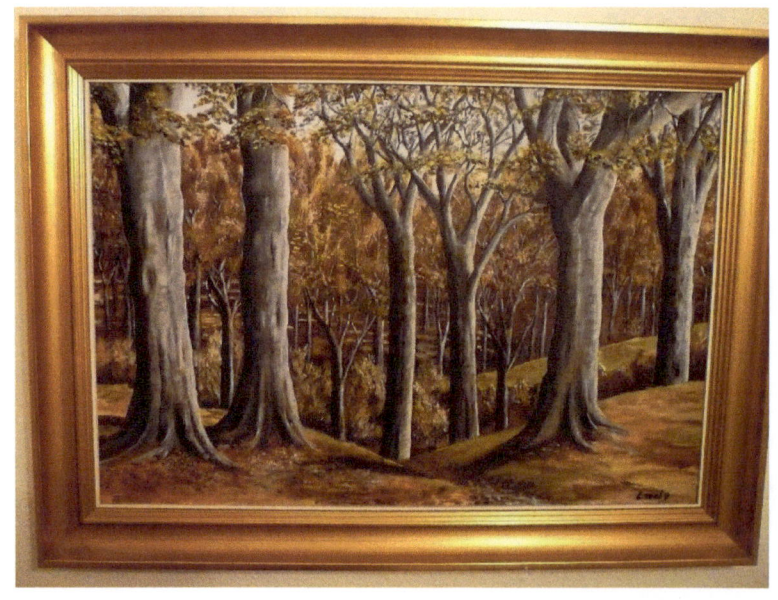

Basque Country.

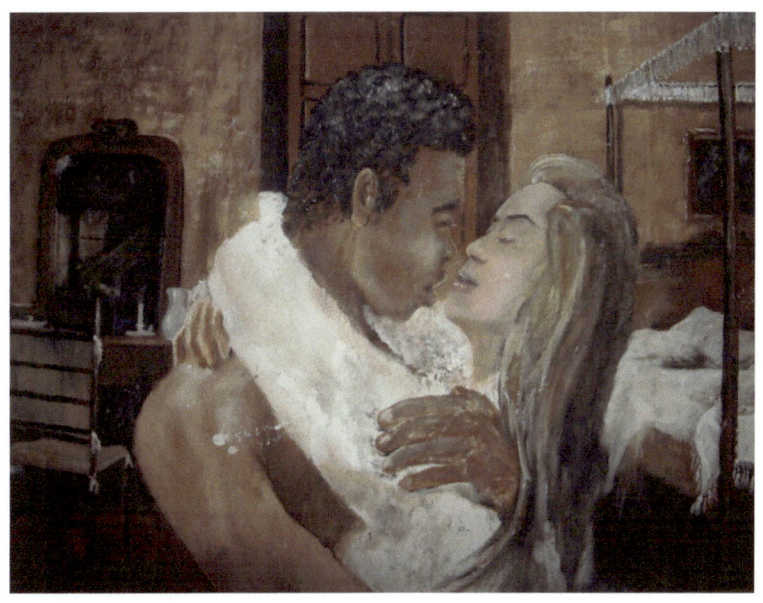

Venezuela.

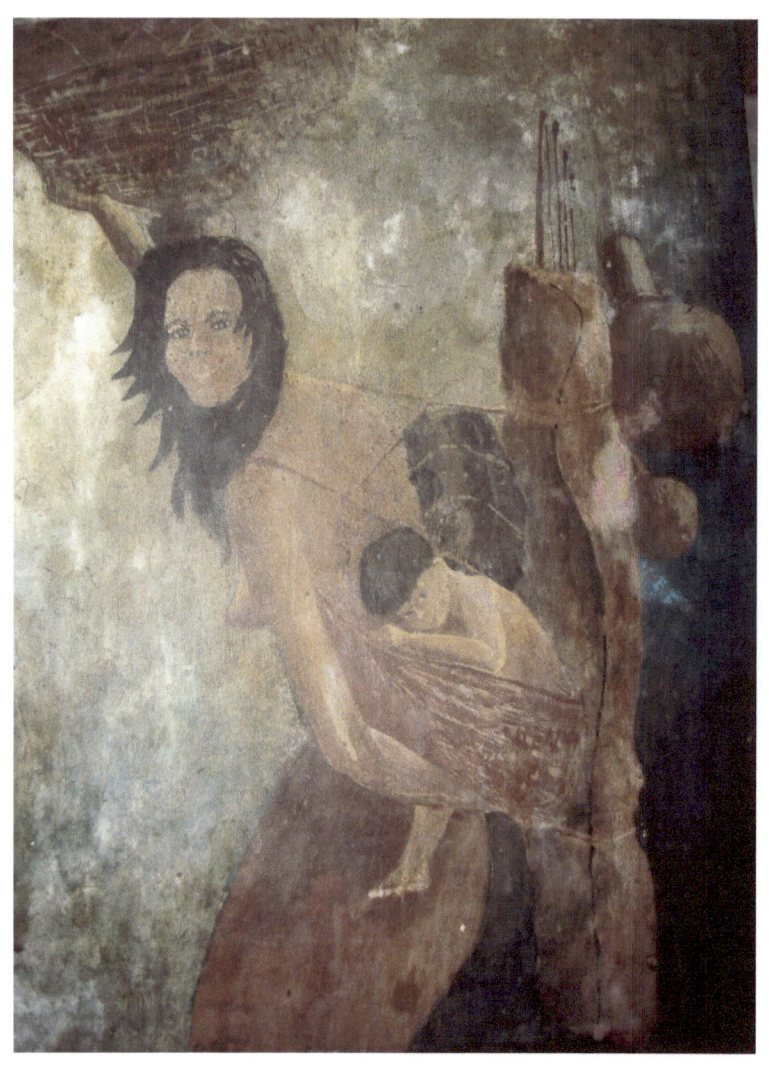

Venezuela. La Gran Sabana. A Pemon mother and her child.

www.ingramcontent.com/pod-product-compliance
Lightning Source LLC
Chambersburg PA
CBHW041108180526
45172CB00001B/163